THE ANTIQUARIAN STICKER BOOK

AN ILLUSTRATED COMPENDIUM OF ADHESIVE EPHEMERA

ODD DOT NEW YORK

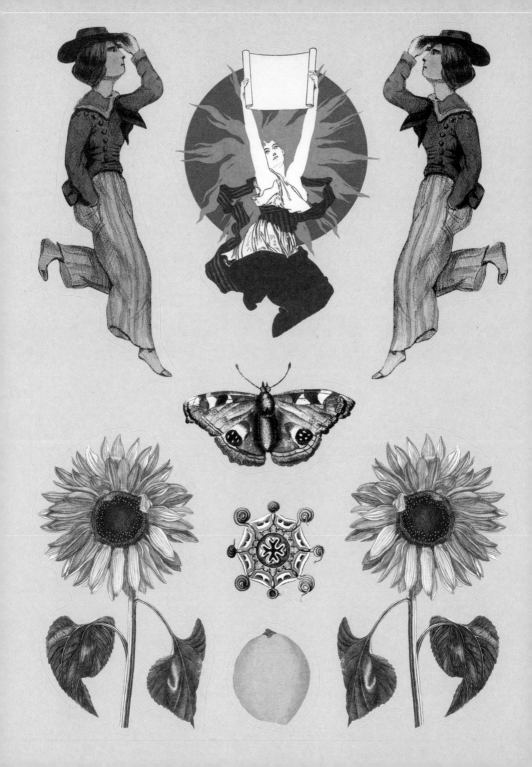

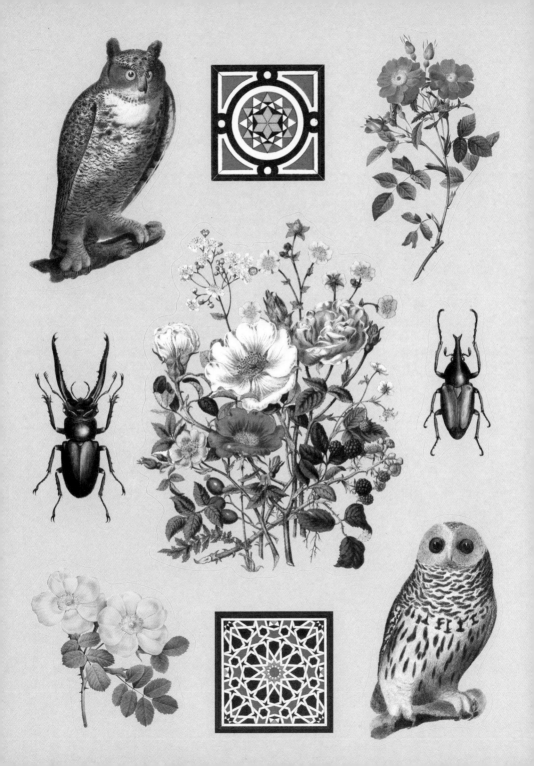

ZONE OF SMALL PLANETS

JUNO
OERES
FLORA
HEBE
PALLAS
MARS
EARTH
VENUS
MERCURY
SUN

MATCHES

BALLAD SINGER

COAL HEAVER

WATER CRESSES

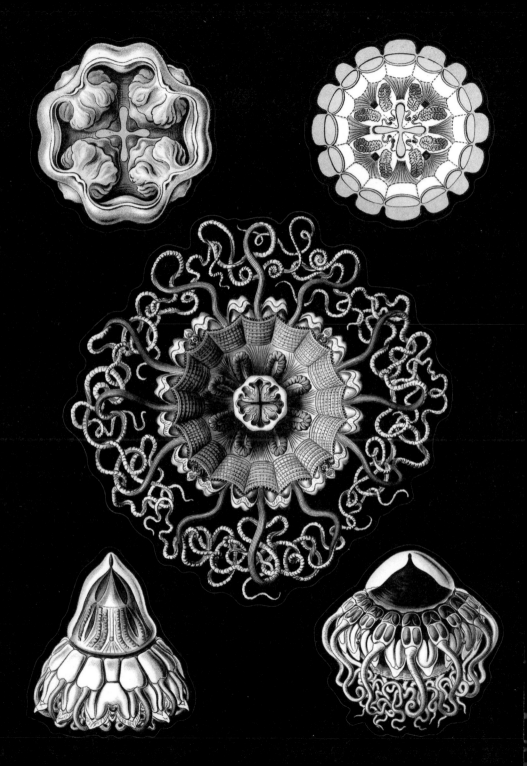

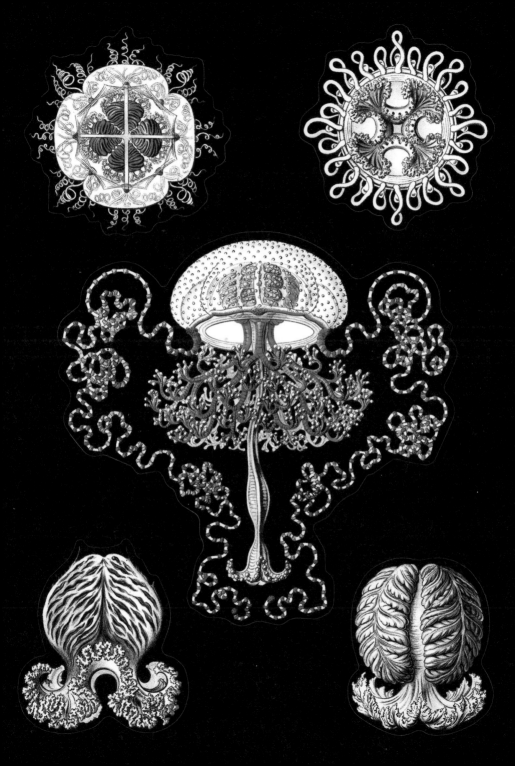

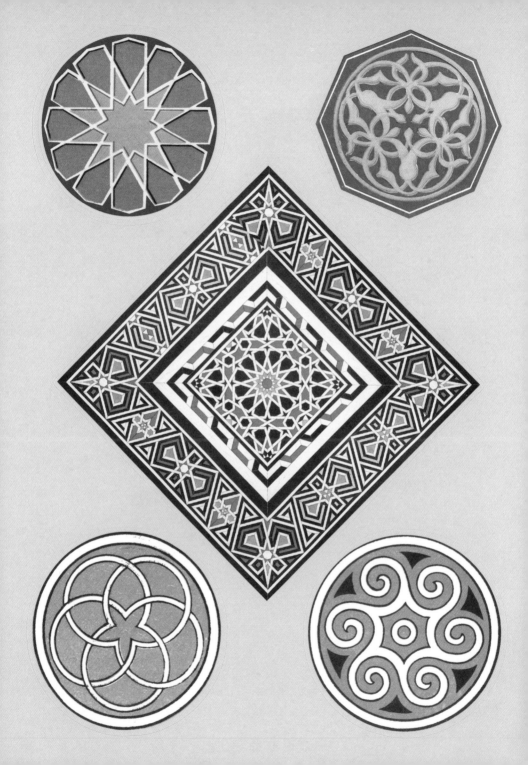

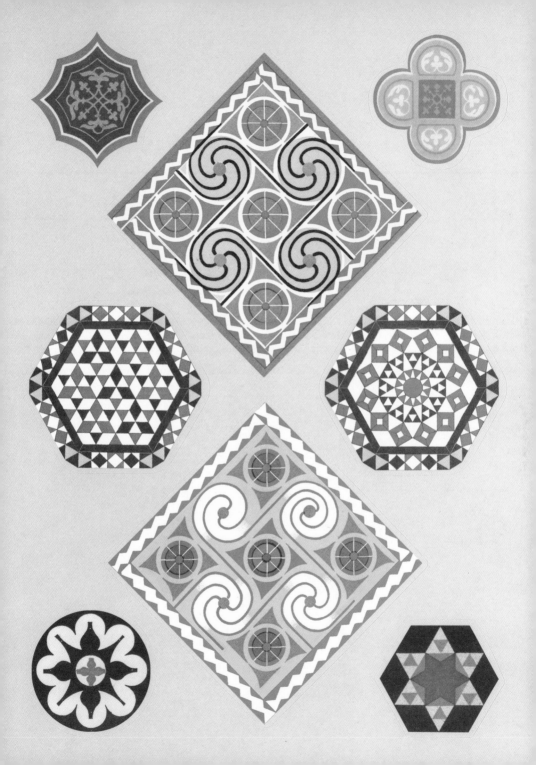

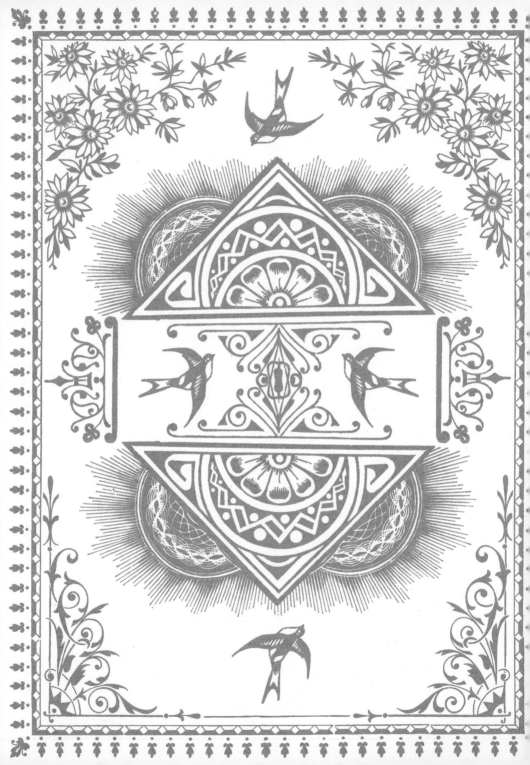

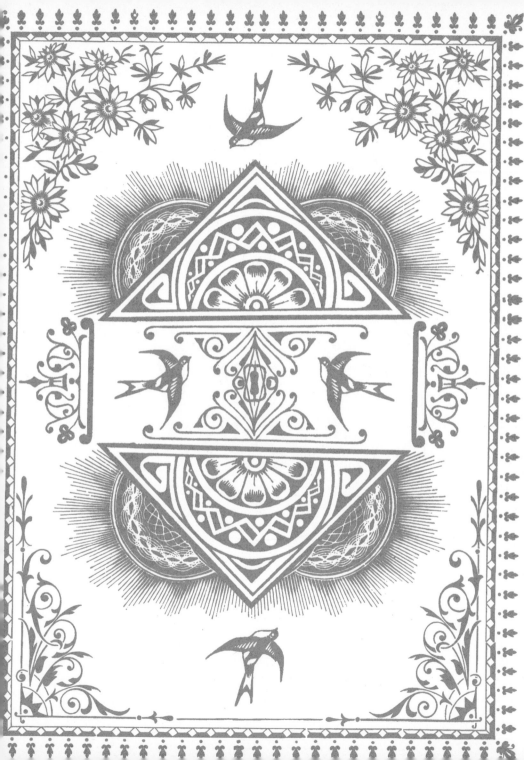

SOCIETY FOR THE REFORMATION OF JUVENILE DELINQUENTS.

HOUSE OF REFUGE.

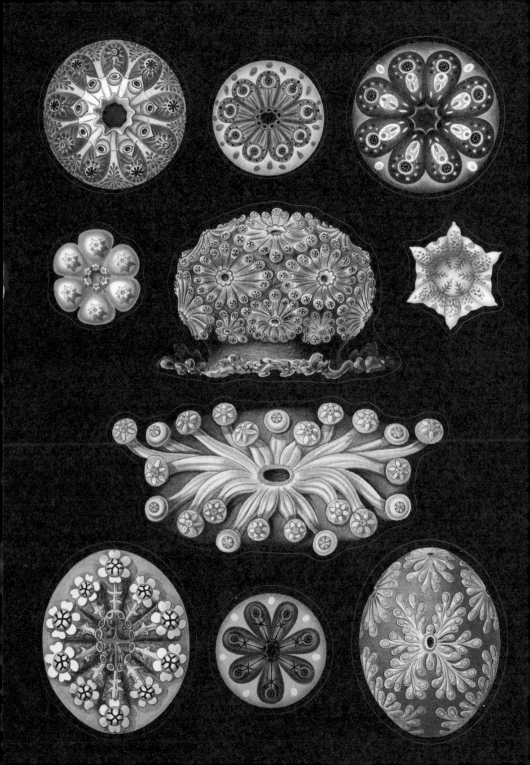

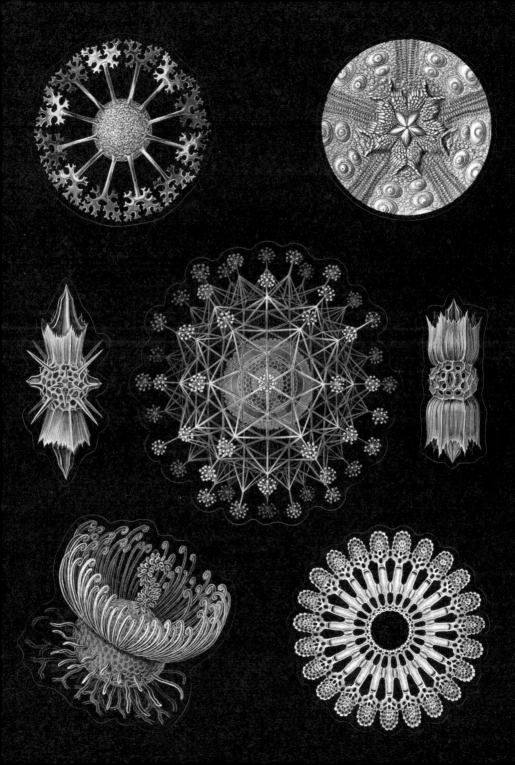

MEMENTO MORI

Laryin Print.

PAS DES MOISSONNEURS

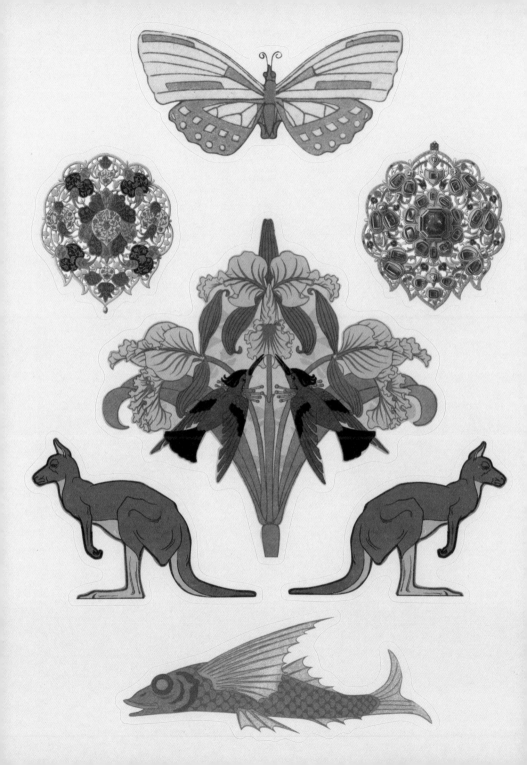

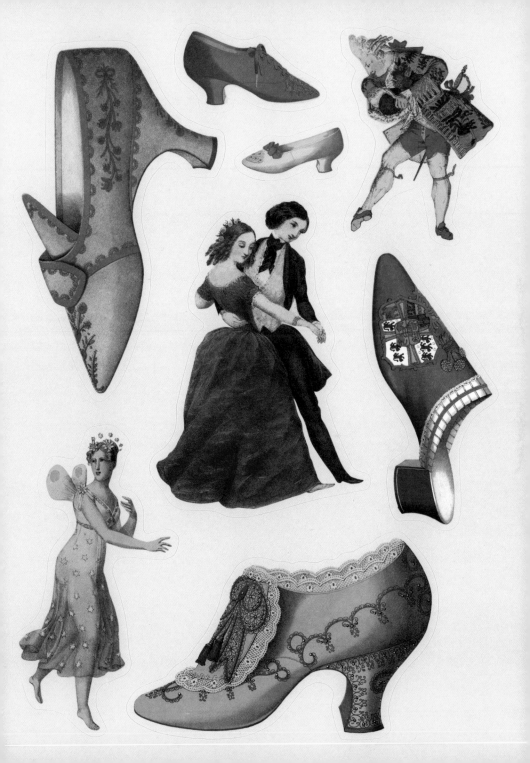

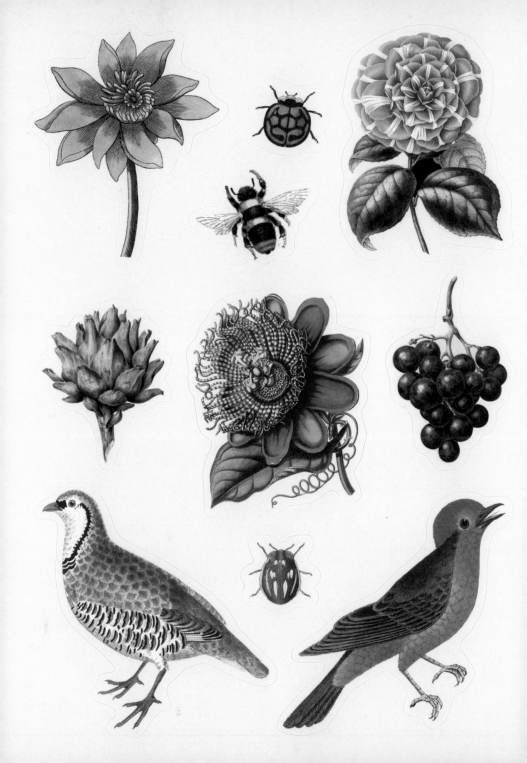

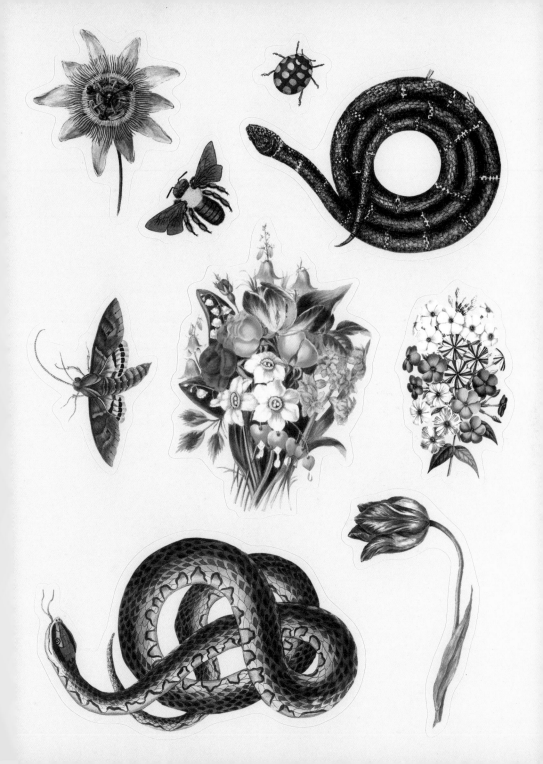

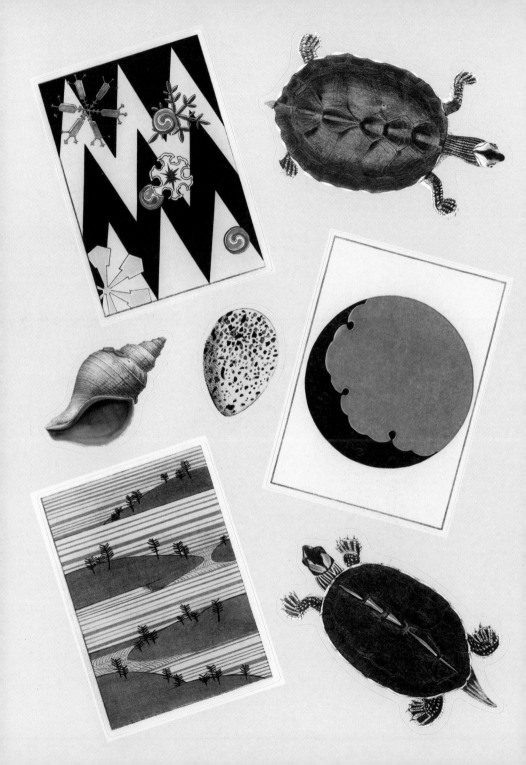

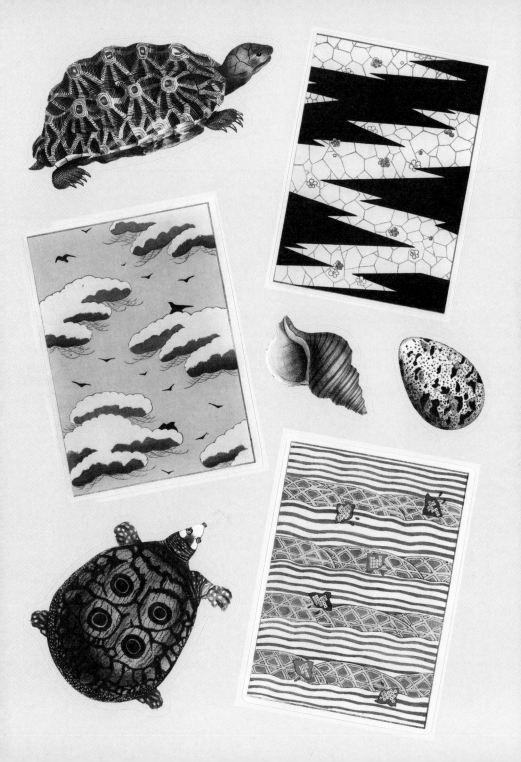

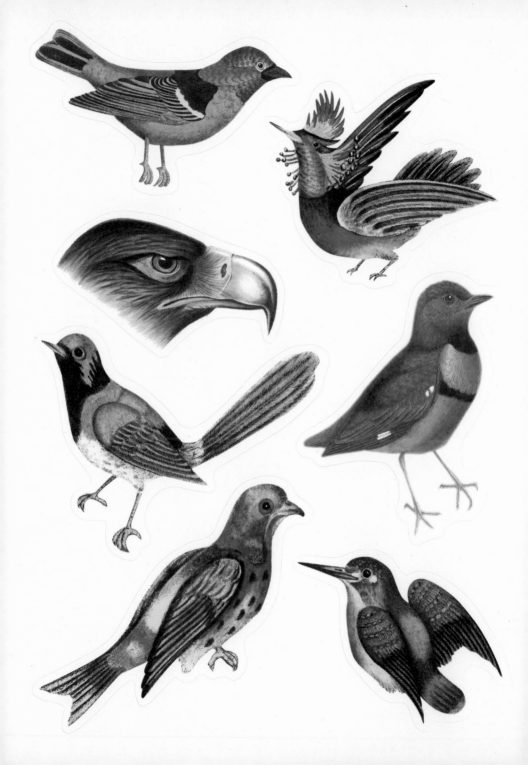

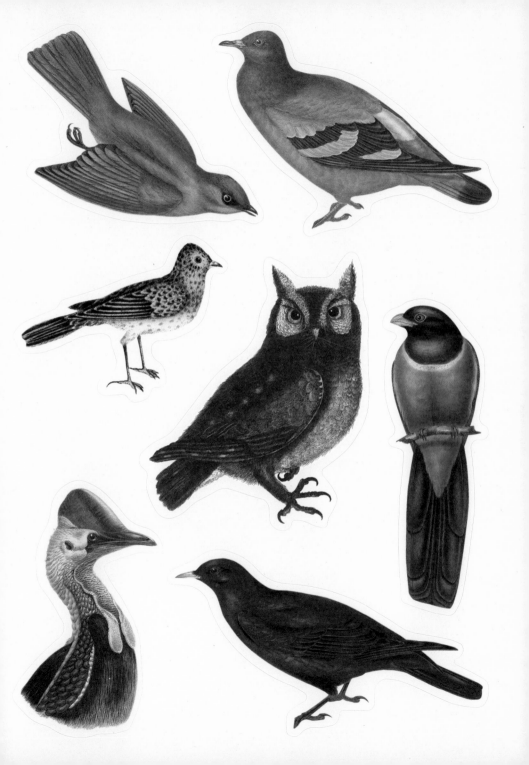

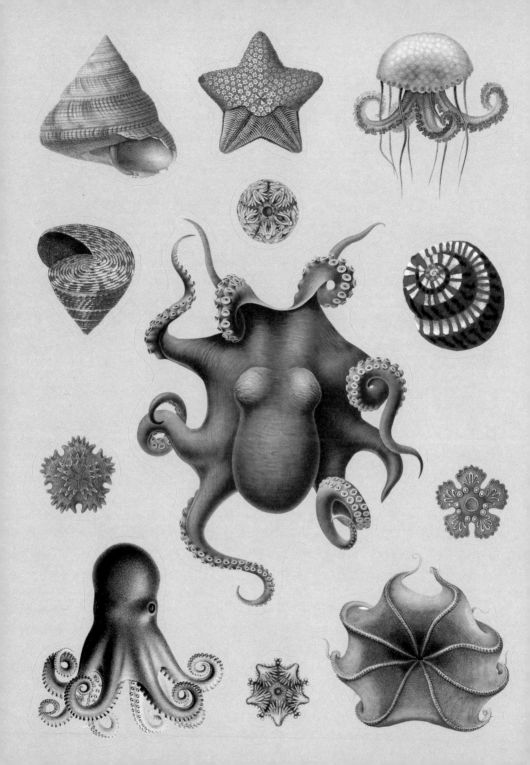

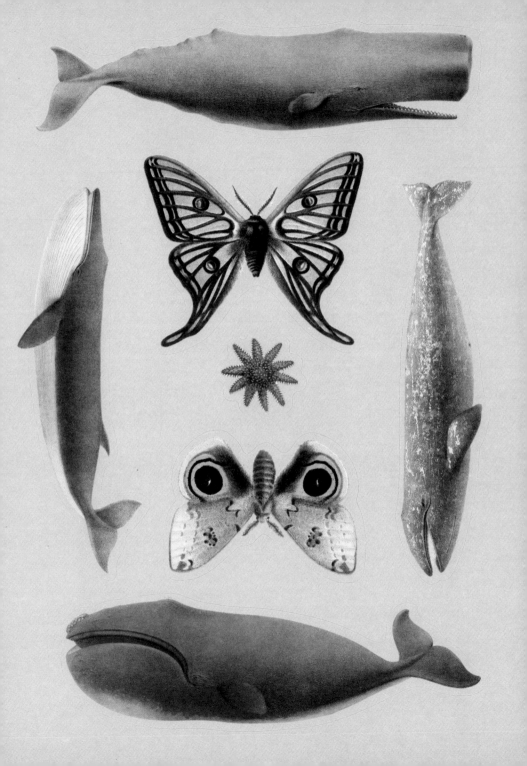

FORGET
ME NOT!

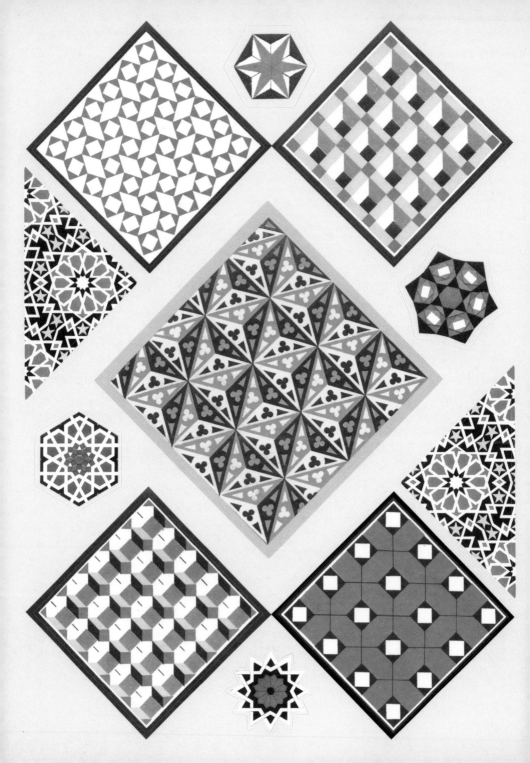

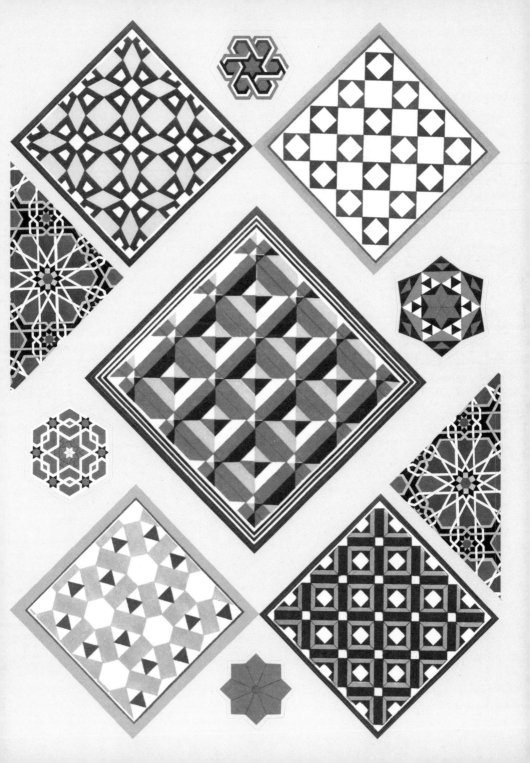

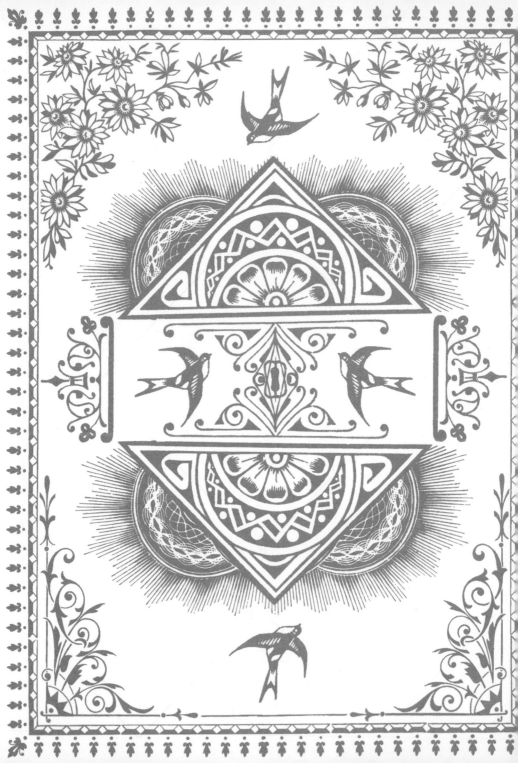

Odd Dot

An imprint of Macmillan Publishing Group, LLC
120 Broadway, New York, NY 10271
OddDot.com

No portion of this book may be reproduced—
mechanically, electronically, or by any other means,
including photocopying—without written permission of the publisher.

ISBN: 978-1-250-20814-9

DESIGNER Tae Won Yu
EDITOR Daniel Nayeri

Our books may be purchased in bulk for promotional, educational, or
business use. Please contact your local bookseller or the Macmillan Corporate
and Premium Sales Department at (800) 221-7945 ext. 5442 or by email at
MacmillanSpecialMarkets@macmillan.com.

Printed in China

First edition, 2020

7 9 10 8 6

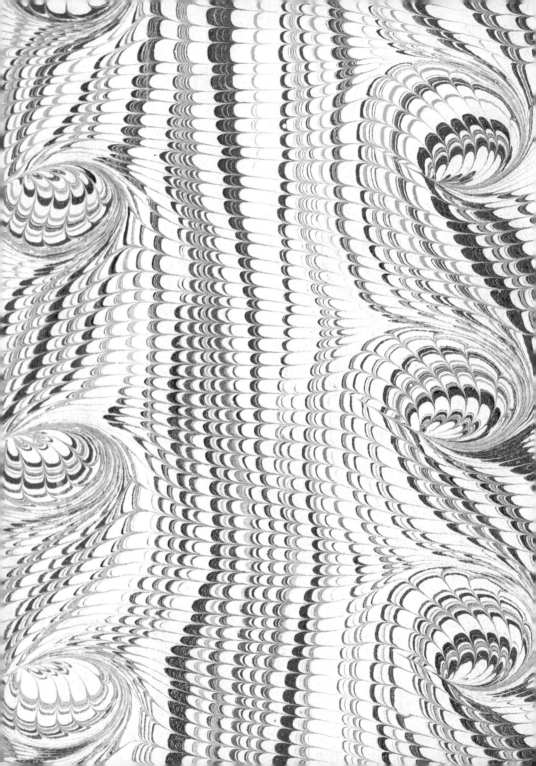